How to Draw
ZOO
ANIMALS

Written and Illustrated by
Jocelyn Schreiber

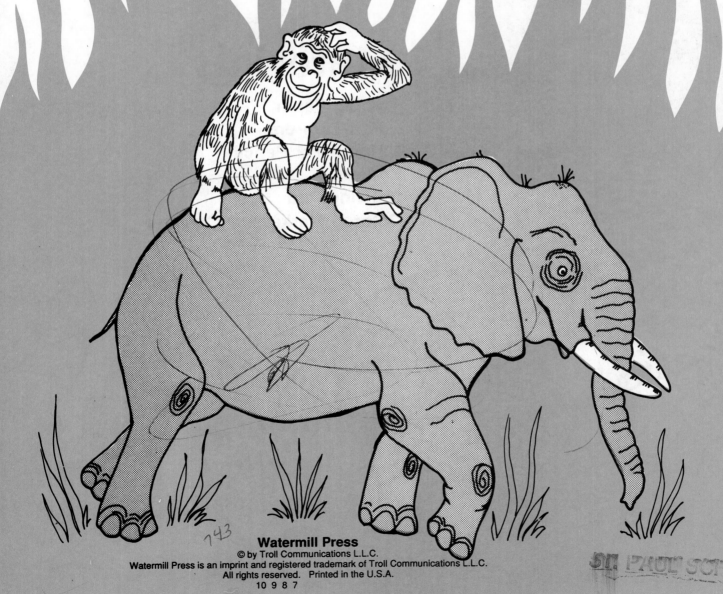

Watermill Press
10 9 8 7

Introduction

Where can you go to see tigers and monkeys, apes and orangutans, camels and donkeys? A wonderful world of animals is waiting for you at the zoo! Would you like to take a stroll through the zoo and draw the creatures that live there?

Before you begin your drawings, you might want to trace over some of the steps. This will show you how to put together the basic shapes that form each animal.

Start your drawing in pencil, so you can erase any unwanted lines. When your animal looks the way you want it to, go over your drawing with a felt-tip pen. Next, color it with crayons or colored markers.

Remember, the best part of your drawing is what *you* add to it with a little imagination—so don't be afraid to experiment! And, most of all, have fun!

Materials

Tracing Paper
2 Felt-Tip Pens
2 Number 2 Pencils
Eraser
Drawing Pad
Colored Markers or Crayons

Lions

Grrowl! The lion lets out a long loud roar.
With its beautiful mane and its proud walk,
it is truly the *King of the Beasts.*
The lions' zoo home is a big open grassland
surrounded by trees and shrubs. It is called
a *natural habitat* because it looks like
the lions' real home in Africa.

A female lion is a *lioness.*
A baby lion is called a *cub.*

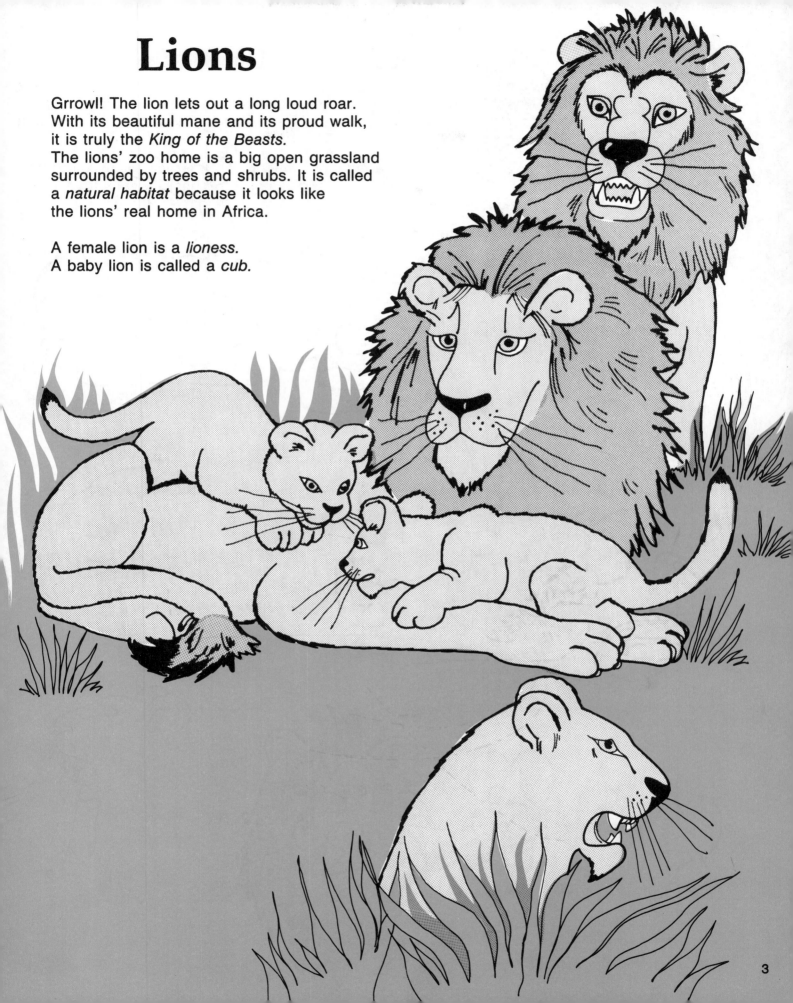

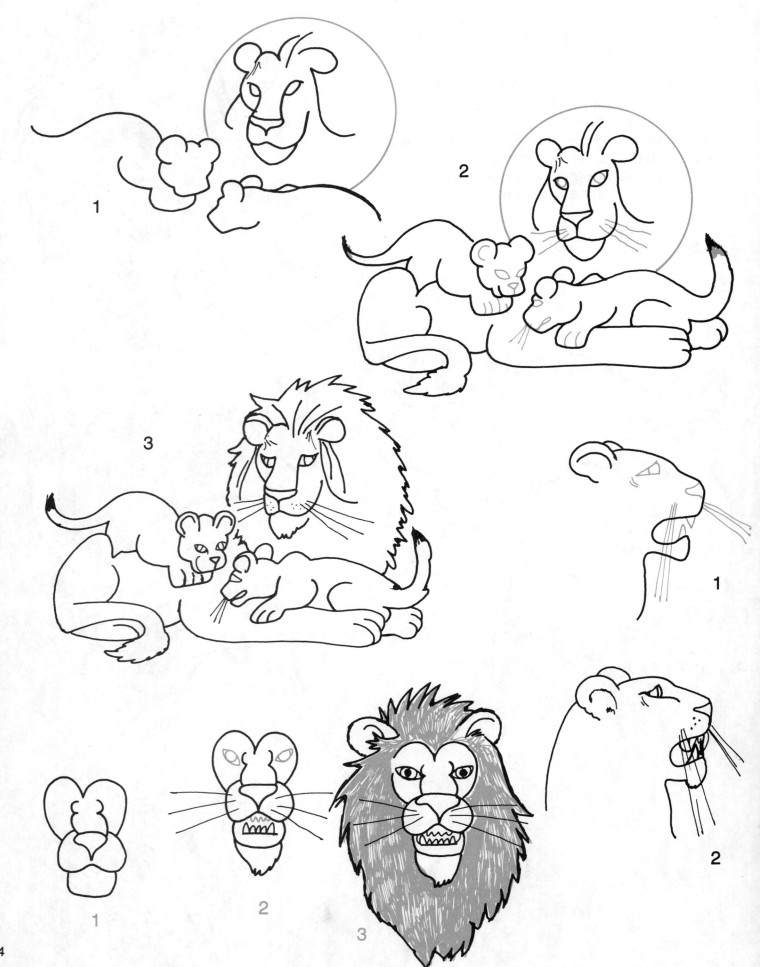

The lion uses its tail to communicate. It carries its tail high in the air as it moves through the tall grass. Since the tip of the tail is easy to see, the other lions can follow.

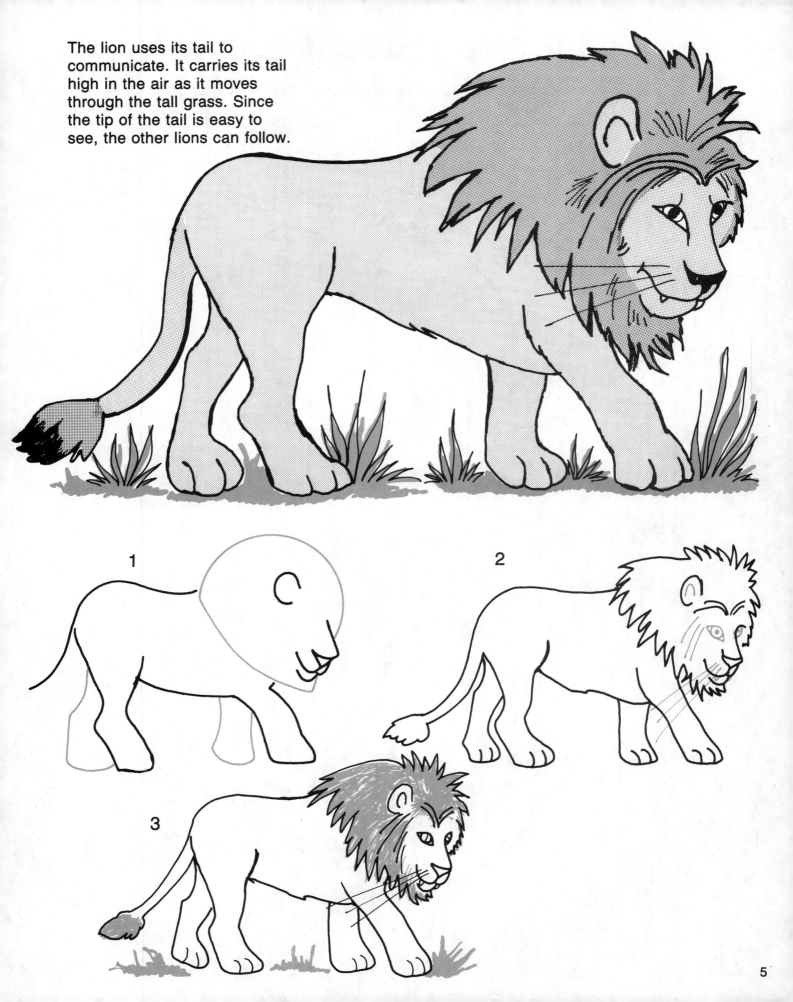

1

2

3

Leopards, Tigers

The leopard lives in jungles, forests, grasslands, and deserts. Its gray or tan color and spotted fur help the leopard hide in trees.

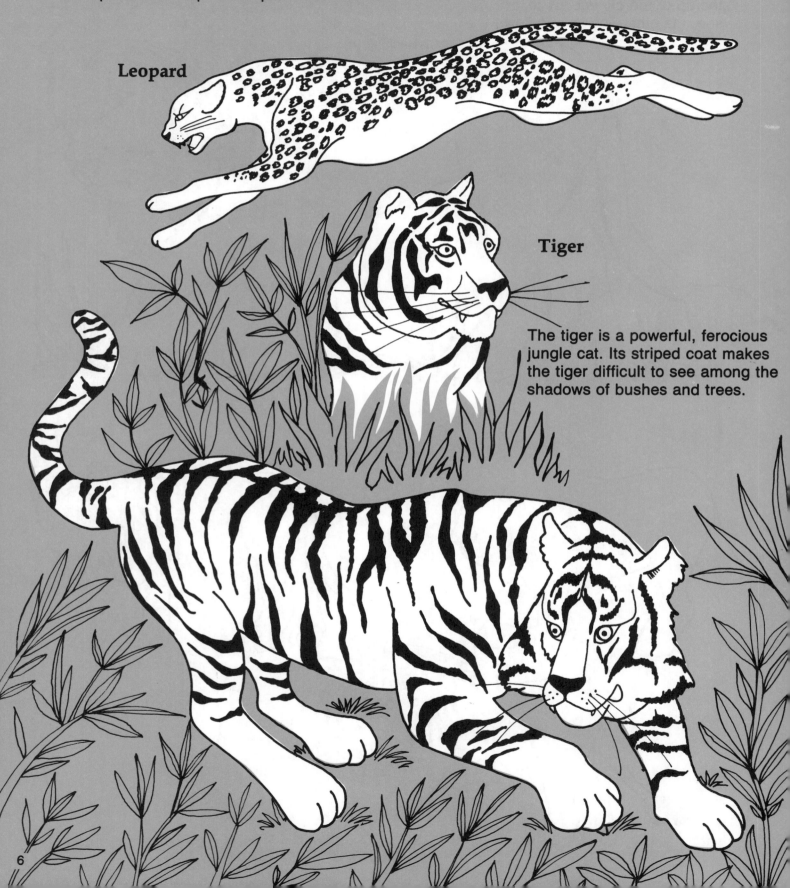

Leopard

Tiger

The tiger is a powerful, ferocious jungle cat. Its striped coat makes the tiger difficult to see among the shadows of bushes and trees.

Leopard

1

2

3

Tiger

1

2

3

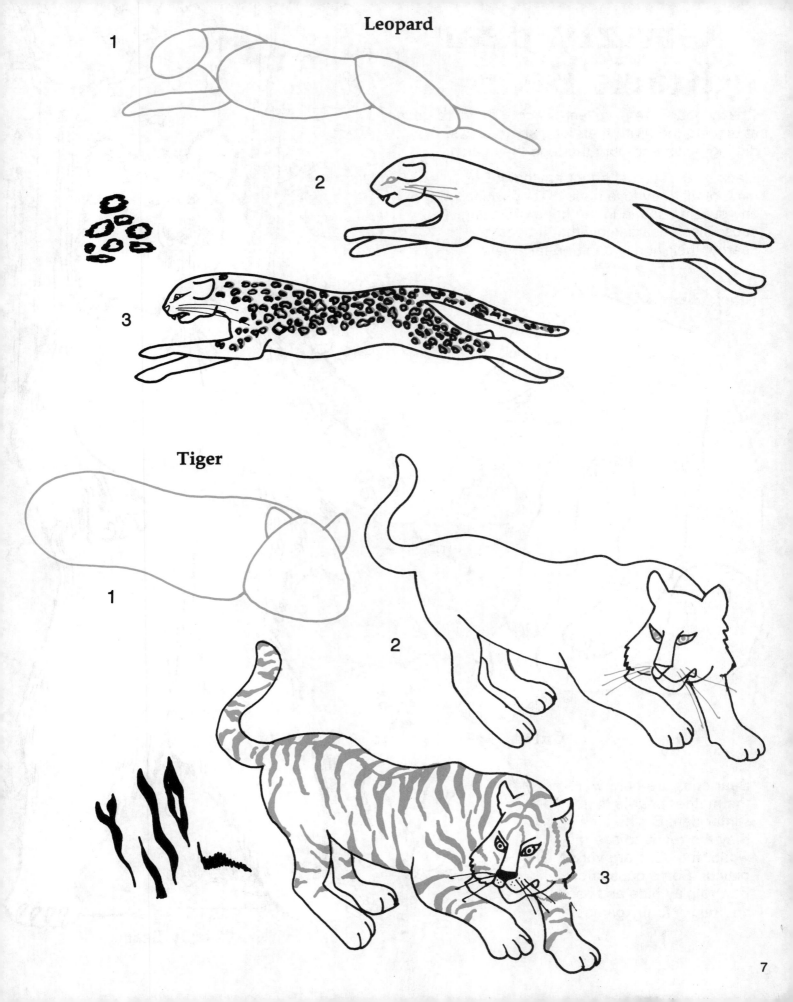

Grizzly Bear, Black Bear

Grizzly bears are excellent fishers. They are good at digging too. With their long sharp claws, they dig big holes and bury the food they catch.

Black bears eat just about anything! But, most of all, they love honey. They will follow any buzzing sound in the hope of finding bees. Black bears know that if bees are nearby, their honey can't be far away.

Black Bear

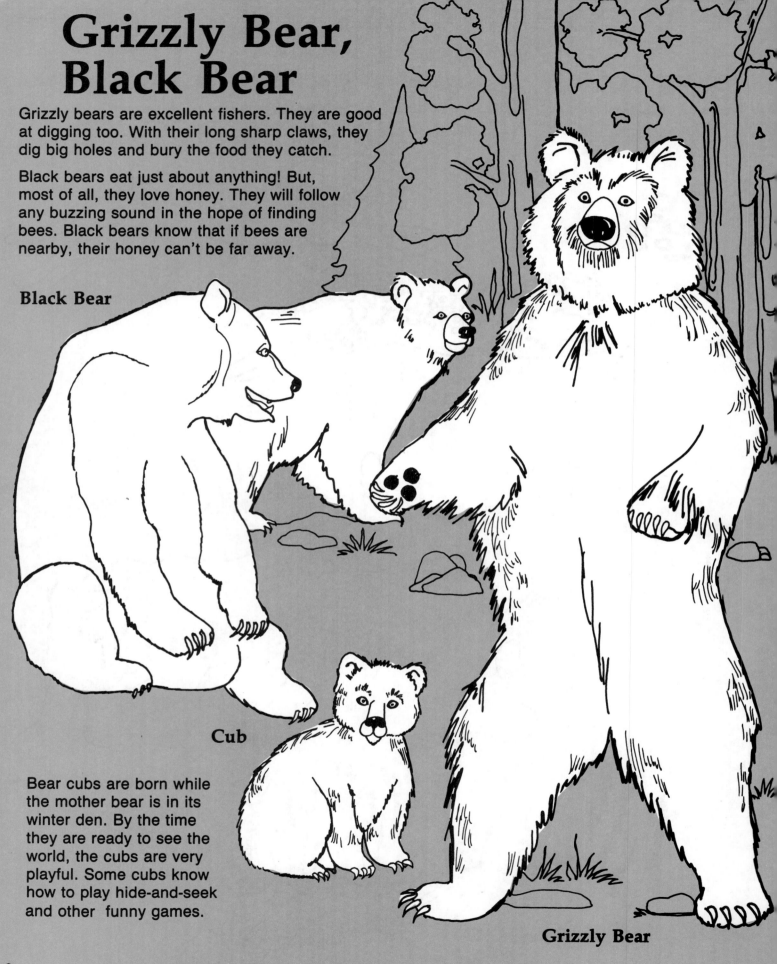

Cub

Bear cubs are born while the mother bear is in its winter den. By the time they are ready to see the world, the cubs are very playful. Some cubs know how to play hide-and-seek and other funny games.

Grizzly Bear

8

Grizzly Bear

1

2

3

Black Bear

1

2

Cub

1

2

3

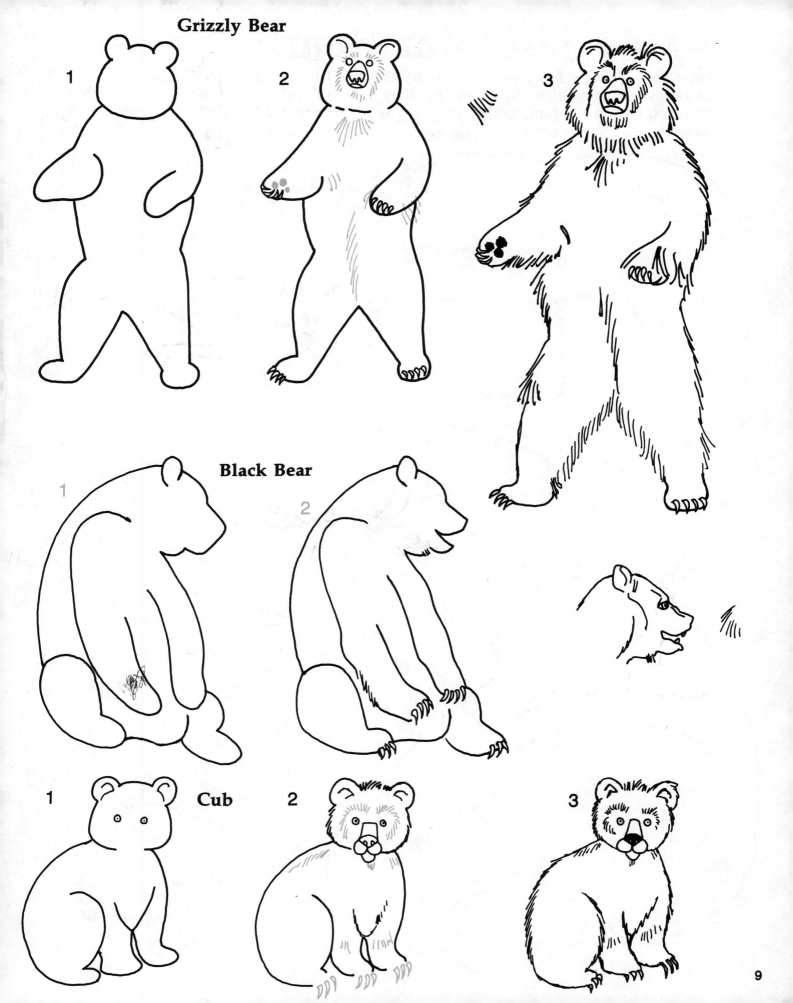

9

Polar Bears

Polar bears live in the cold arctic regions of Russia, Norway, Denmark, Canada, and the United States. With their snow-white fur, they are hard to distinguish from the snow banks on which they live. When hunting for food, the polar bear covers its little black nose with its paw. Can you guess why?

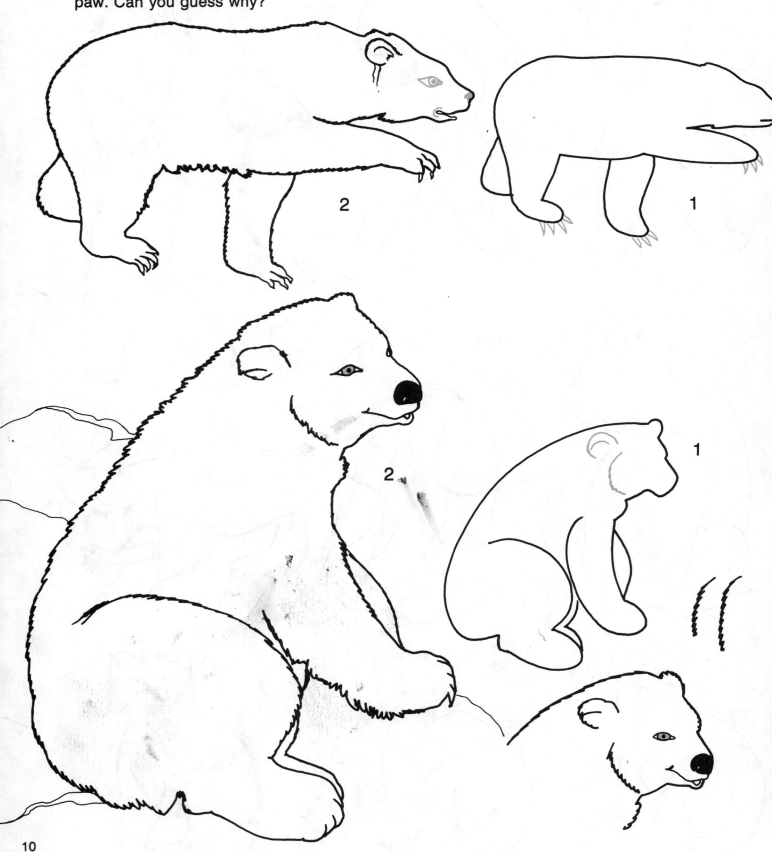

Pandas

Pandas live in the forests of China and love to eat bamboo!

Some scientists say
that pandas are more
like raccoons than
bears.

Look at the pictures of
the pandas on this
page. What do *you*
think about pandas?

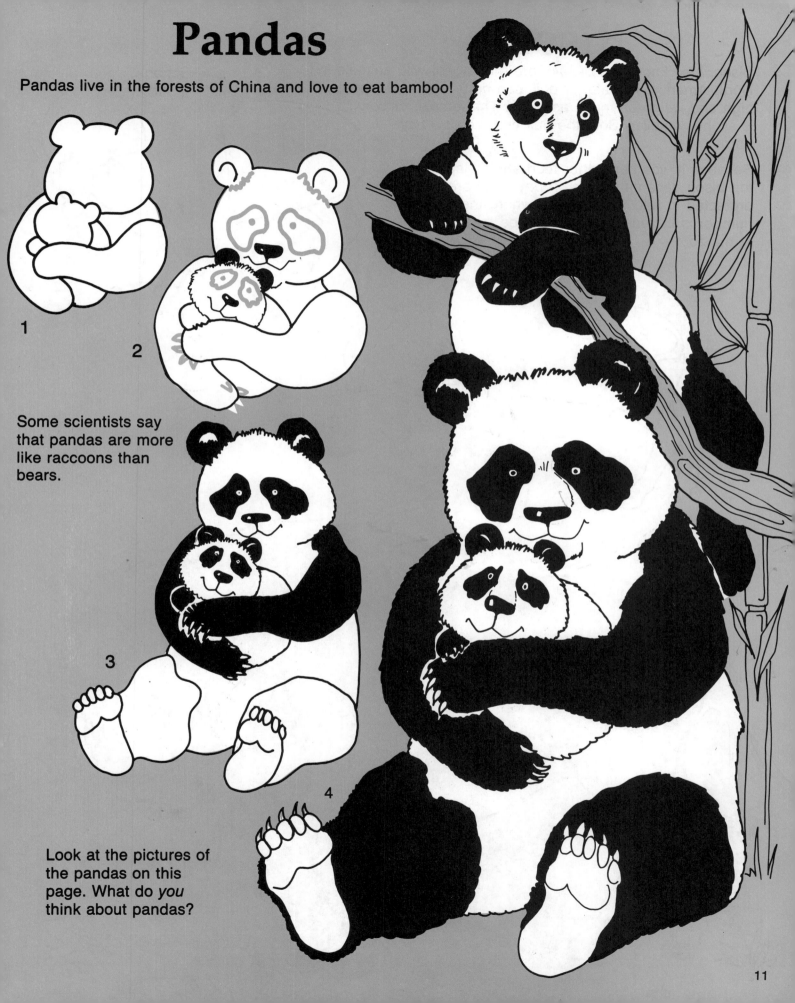

1

2

3

4

Bison

Bison, also known as *buffalo,* are the largest wild animals in North America. A male, or *bull,* can be 6 feet, or 2 meters, high and weigh as much as a ton. The female, or *cow,* is slightly smaller. Both the bull and the cow have horns.

Because it was hunted for food and for sport, the bison became scarce. Today, they are protected in wildlife preserves where their number is increasing. You can see them at the zoo!

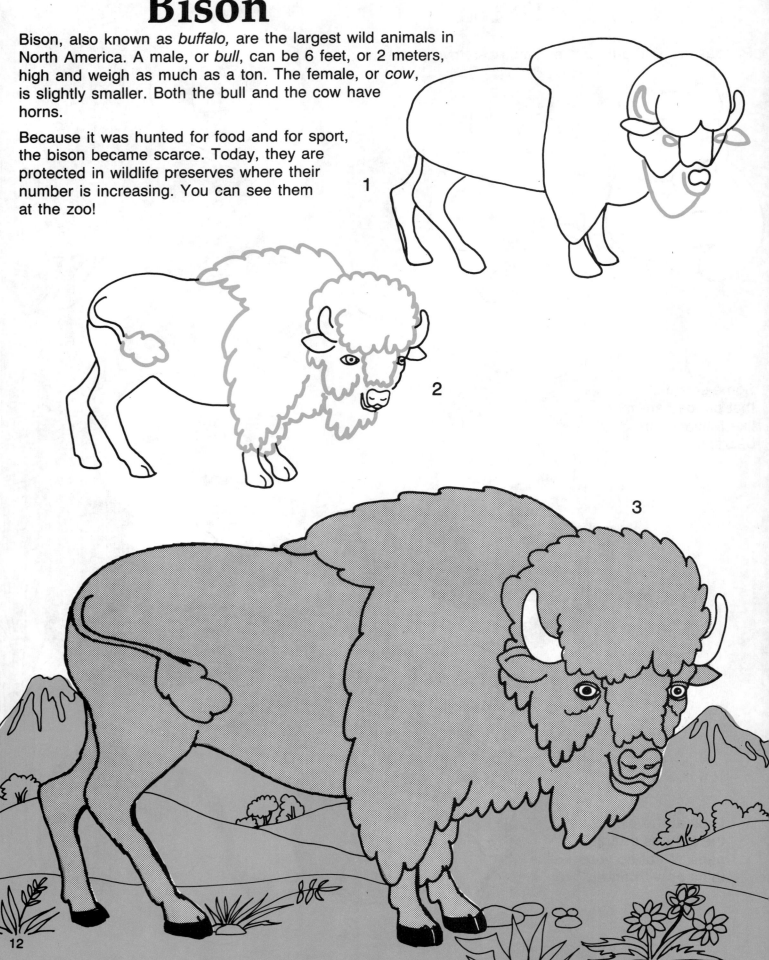

Zebras

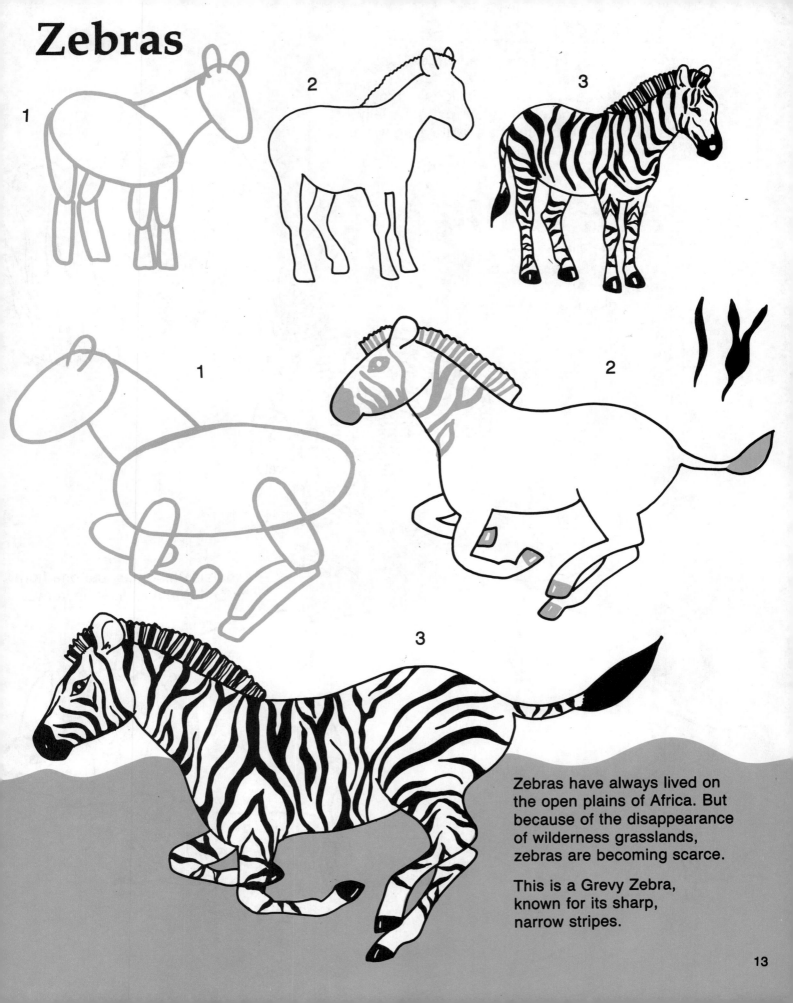

Zebras have always lived on the open plains of Africa. But because of the disappearance of wilderness grasslands, zebras are becoming scarce.

This is a Grevy Zebra, known for its sharp, narrow stripes.

Rhinoceros

The rhinoceros is one of the three largest land animals in the world. The rhino is quite a bad-tempered beast, quick to attack its enemy. It lowers its head and charges out, but it usually misses its target. The rhino has bad eyesight and can't see where it's going!

Armadillo

The armadillo's bony coat of armor is its own natural protection. It rolls itself up in a tight little ball whenever it spots its enemy.

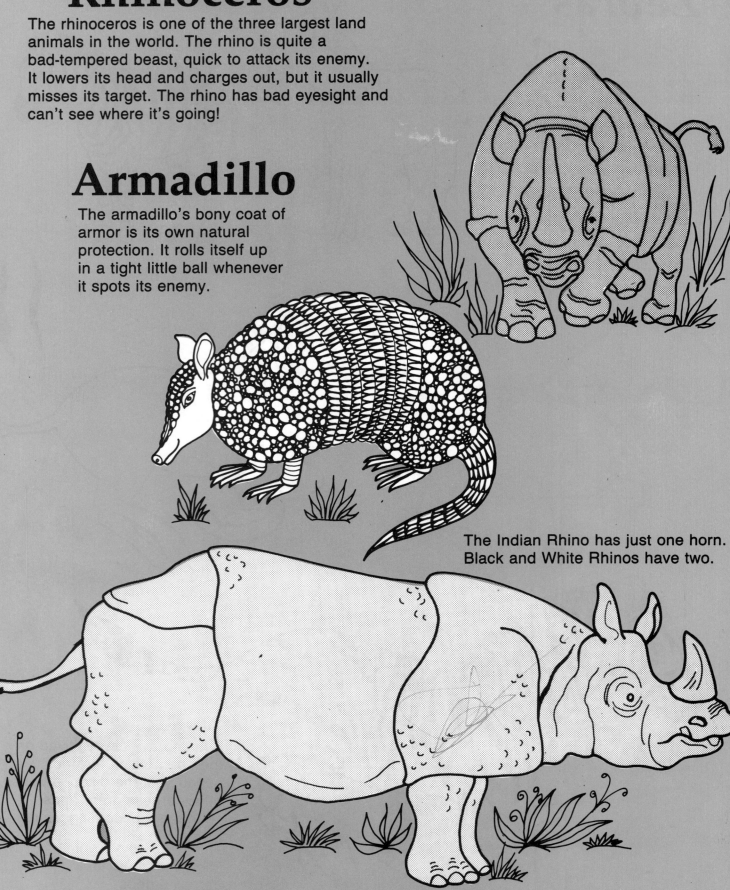

The Indian Rhino has just one horn. Black and White Rhinos have two.

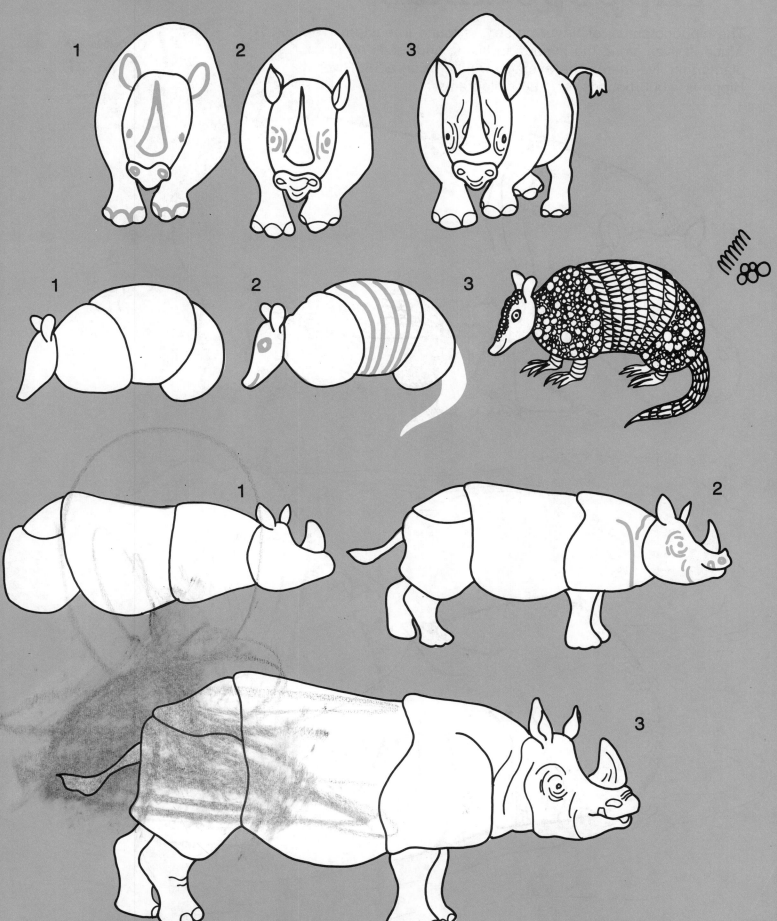

1

2

3

1

2

3

1

2

3

15

Hippopotamus

The hippopotamus, or "river horse," is found in eastern Africa. It lives along the rivers and lakes, and feeds on the plants that live there. The average weight of an adult River Hippo is 4,000 pounds, or 1,800 kilograms.

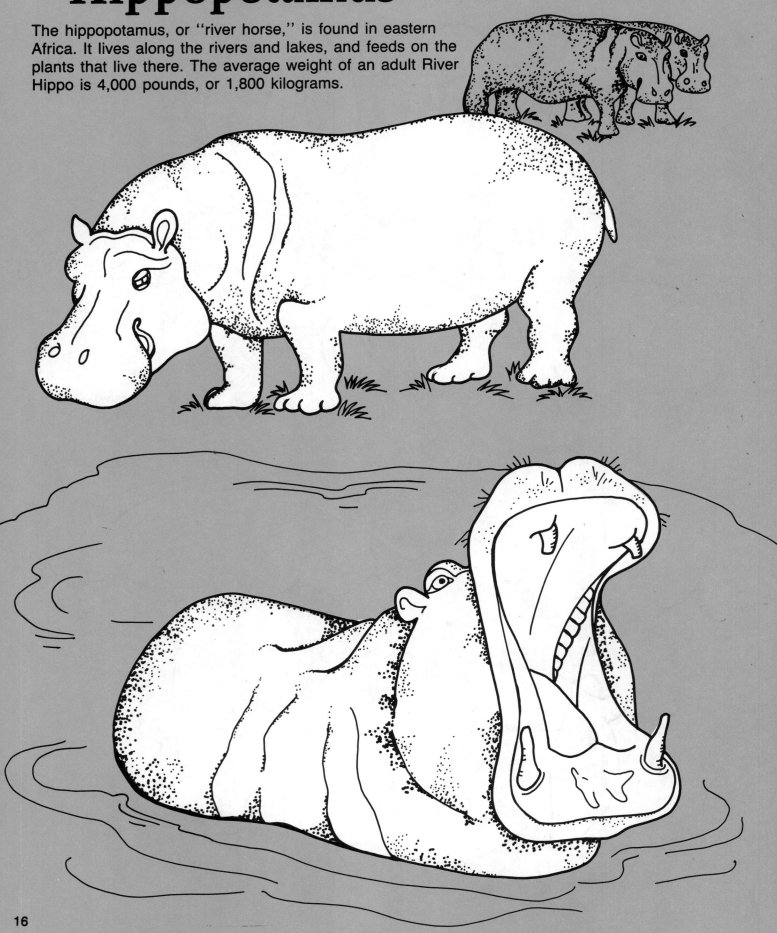

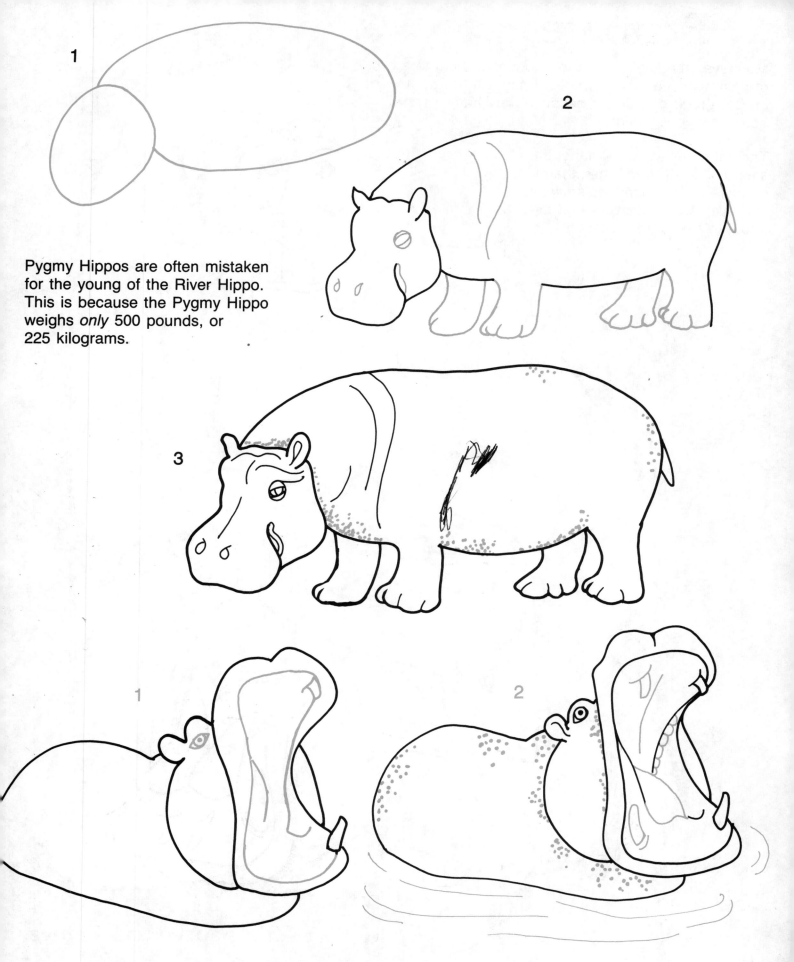

1

2

Pygmy Hippos are often mistaken for the young of the River Hippo. This is because the Pygmy Hippo weighs *only* 500 pounds, or 225 kilograms.

3

1

2

Primates

Monkeys, apes, gorillas, and baboons belong to a group of animals called the *primates.* They are the prime, or top, group of animals because they have the best-developed brains.

The chimpanzee is, perhaps, the smartest of all. *And* it has the most expressive face. Chimps smile, scowl, and even look puzzled—as if they're about to ask you a question!

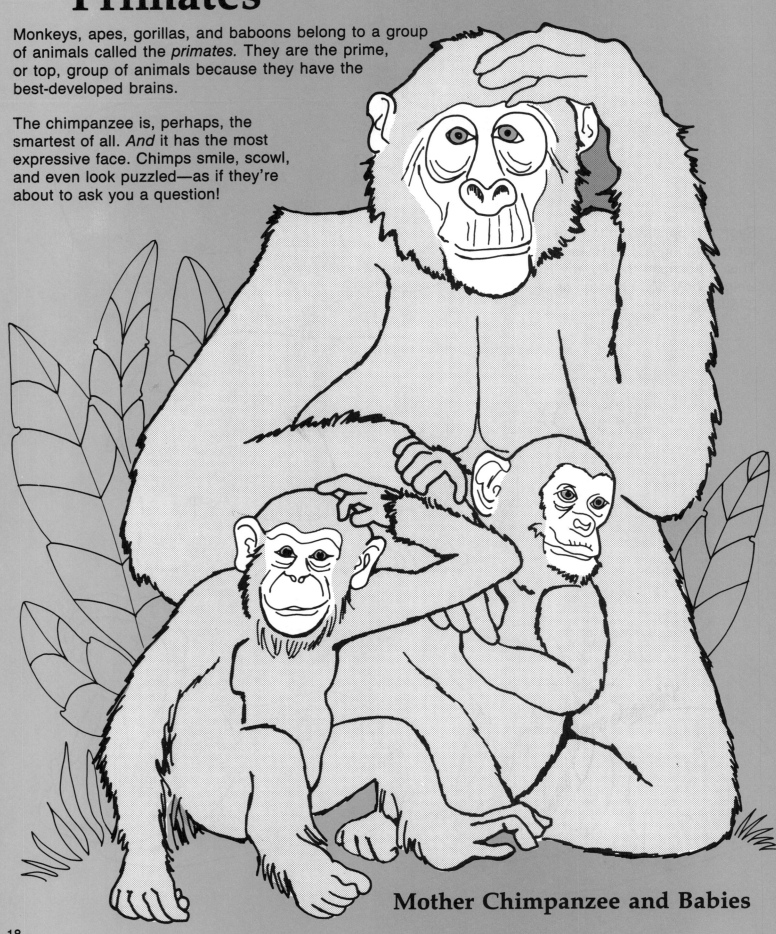

Mother Chimpanzee and Babies

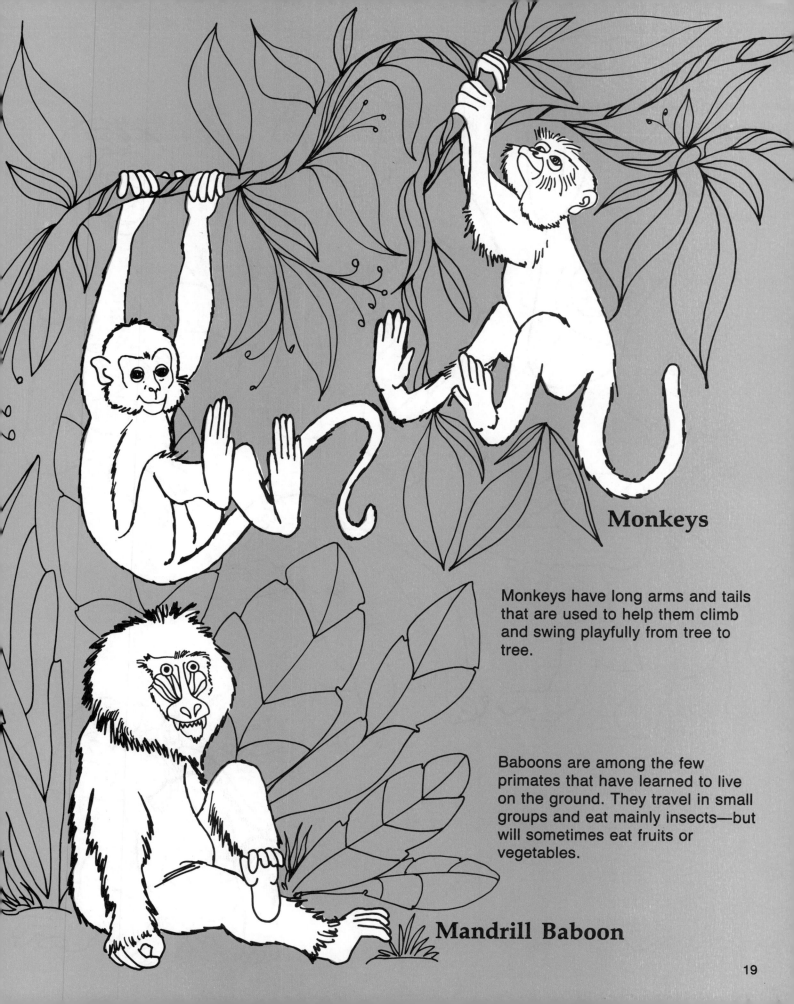

Monkeys

Monkeys have long arms and tails
that are used to help them climb
and swing playfully from tree to
tree.

Baboons are among the few
primates that have learned to live
on the ground. They travel in small
groups and eat mainly insects—but
will sometimes eat fruits or
vegetables.

Mandrill Baboon

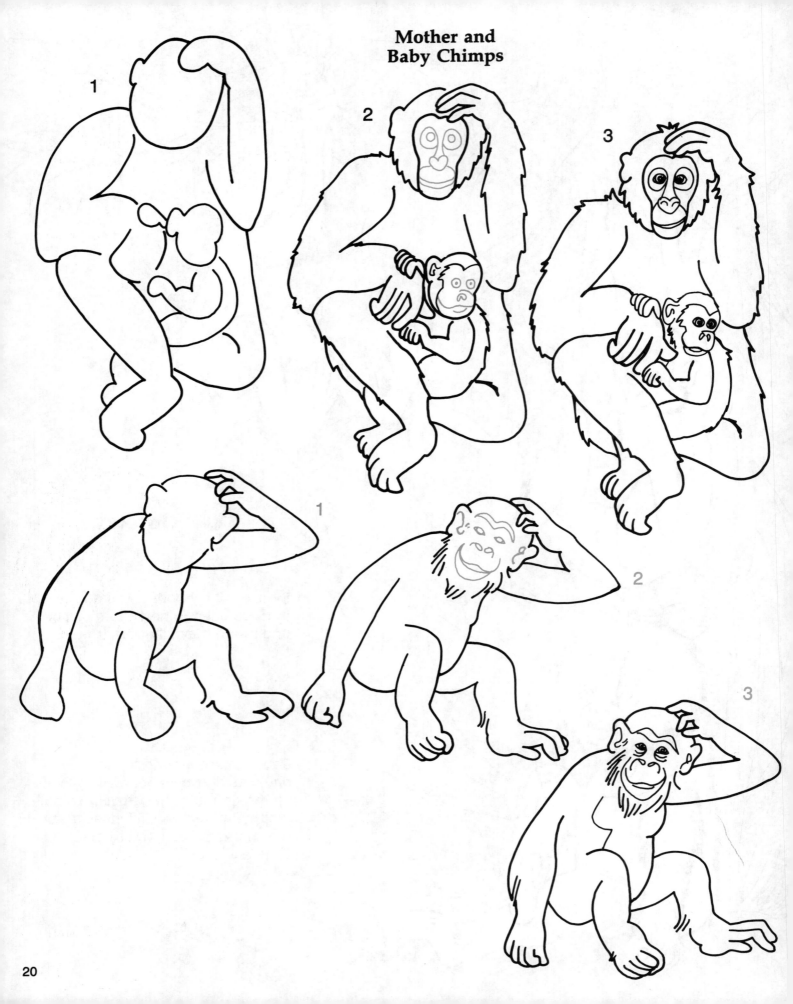

Monkey

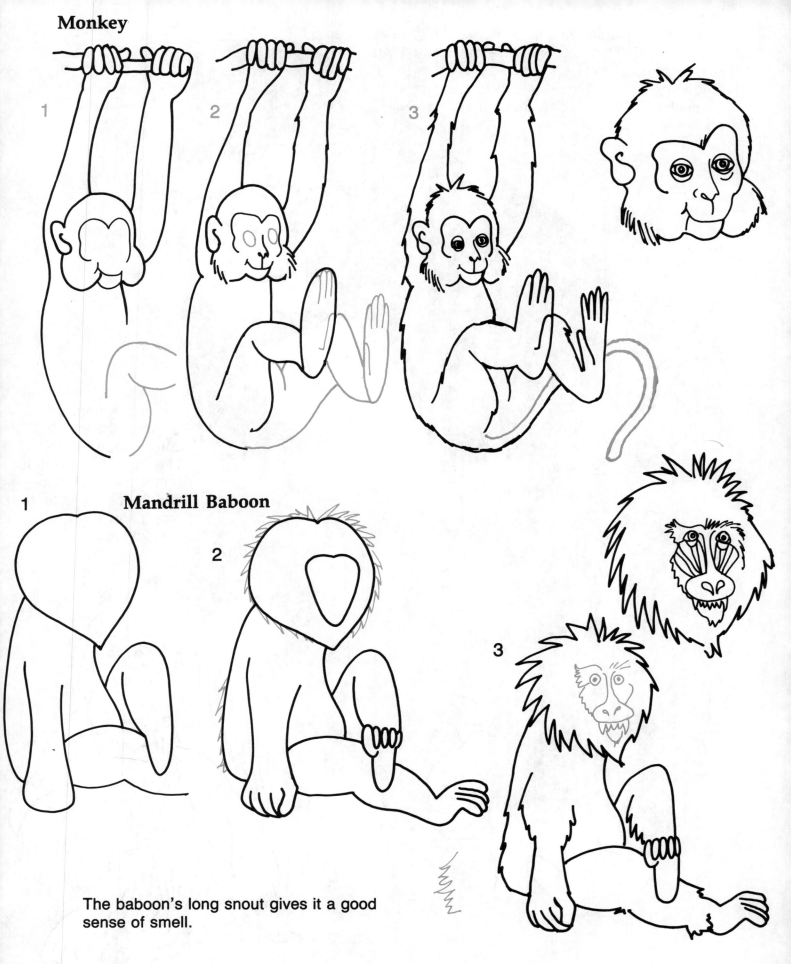

Mandrill Baboon

The baboon's long snout gives it a good sense of smell.

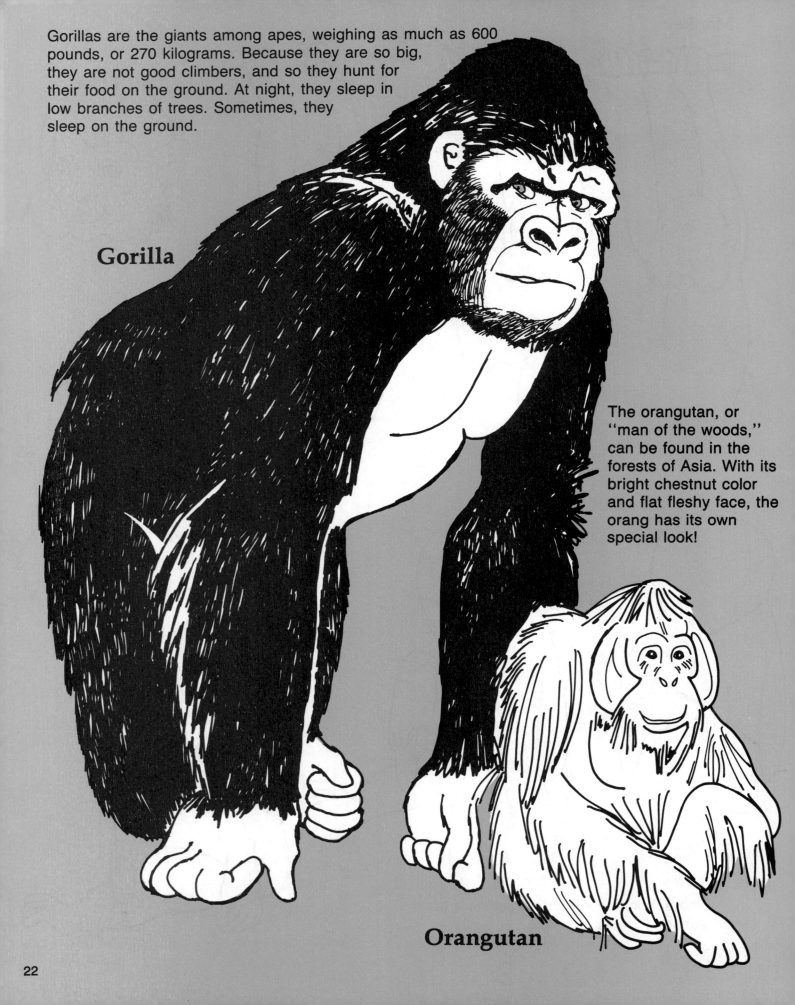

Gorillas are the giants among apes, weighing as much as 600 pounds, or 270 kilograms. Because they are so big, they are not good climbers, and so they hunt for their food on the ground. At night, they sleep in low branches of trees. Sometimes, they sleep on the ground.

Gorilla

The orangutan, or "man of the woods," can be found in the forests of Asia. With its bright chestnut color and flat fleshy face, the orang has its own special look!

Orangutan

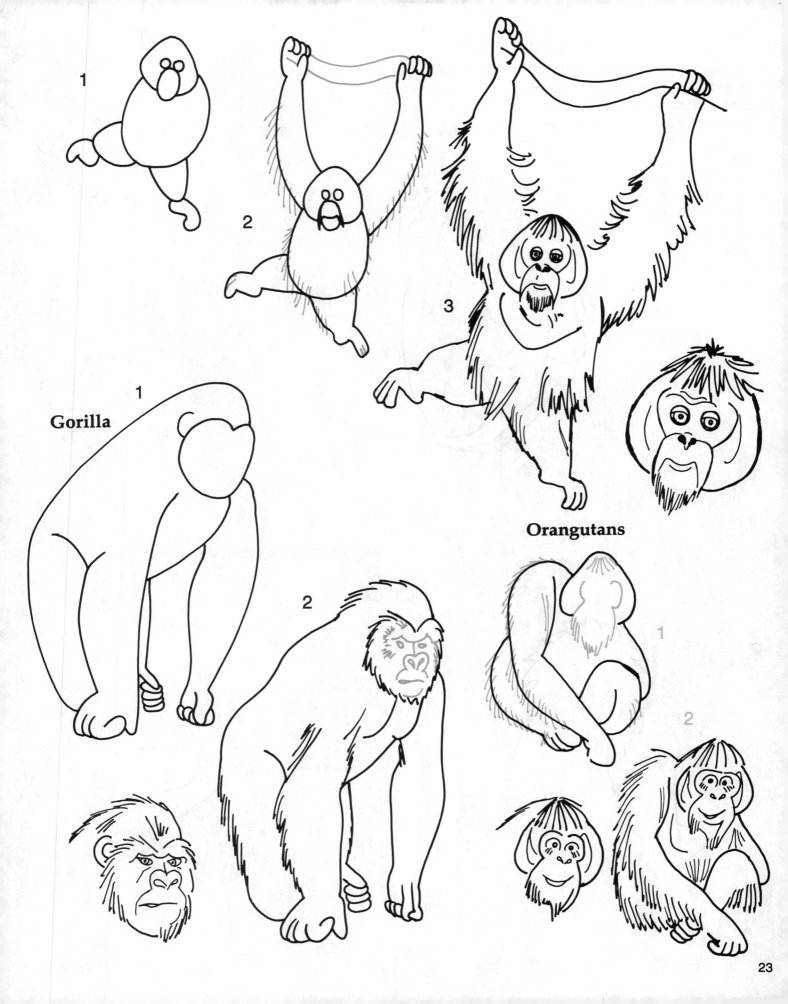

1

2

3

Gorilla

1

2

Orangutans

1

2

Giraffes

Giraffes are the tallest animals in the world.
A giraffe's legs are so long that a full-grown person
could stand upright between them! The giraffe has
a long neck too. Because of its neck, the giraffe has
an advantage over other animals
on the dry plains of Africa. The
giraffe can reach all the way
up to eat the leaves on the
trees. And it can spot an
enemy a *long* distance
away!

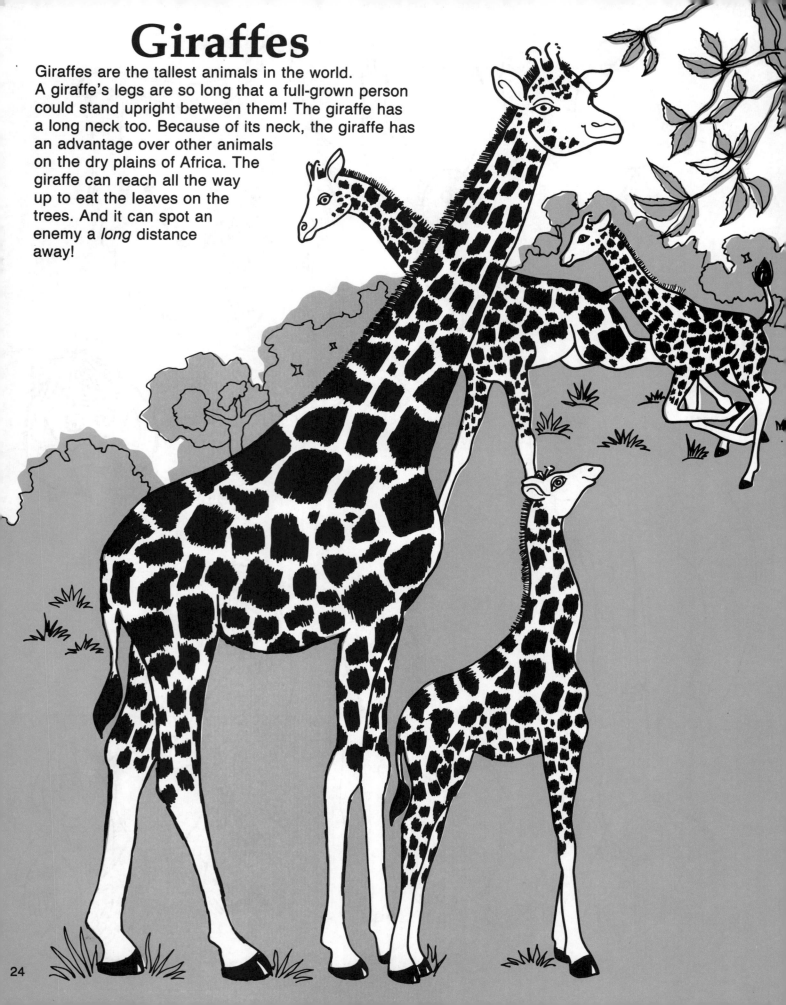

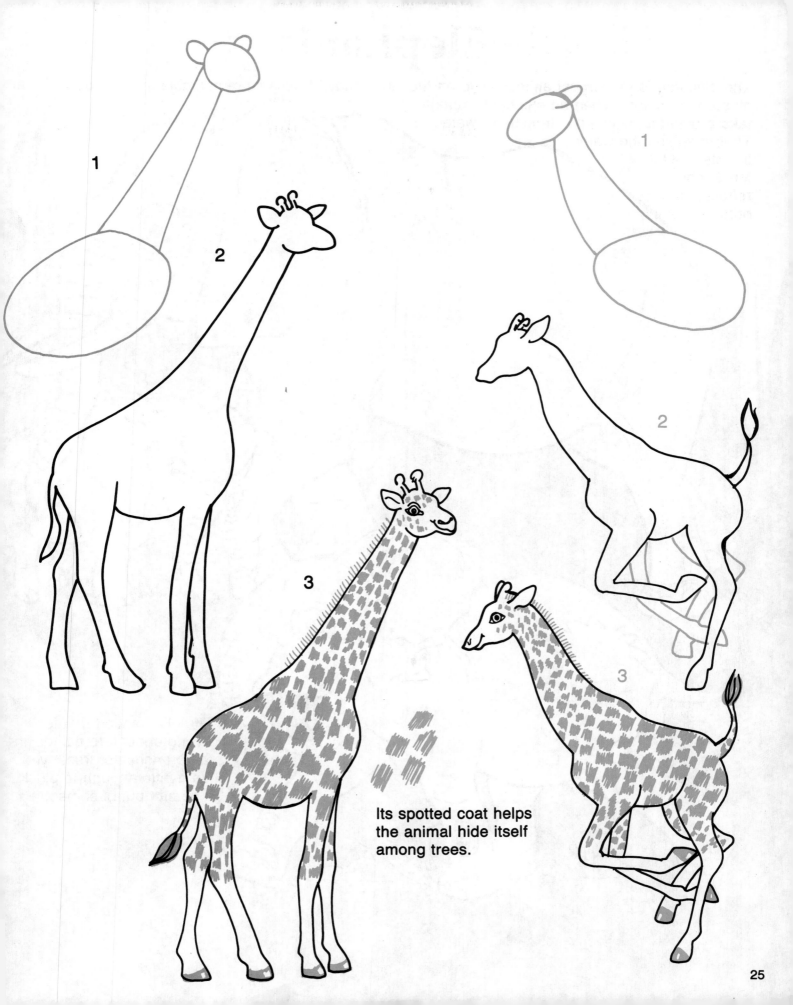

1

2

3

Its spotted coat helps
the animal hide itself
among trees.

1

2

3

Elephants

The elephant is the largest animal living on the land today. It uses its remarkable trunk to do all sorts of things. When an elephant wants to take a drink, it sucks up a trunkful of water. Then it squirts the water into its mouth for a cool refreshing drink!

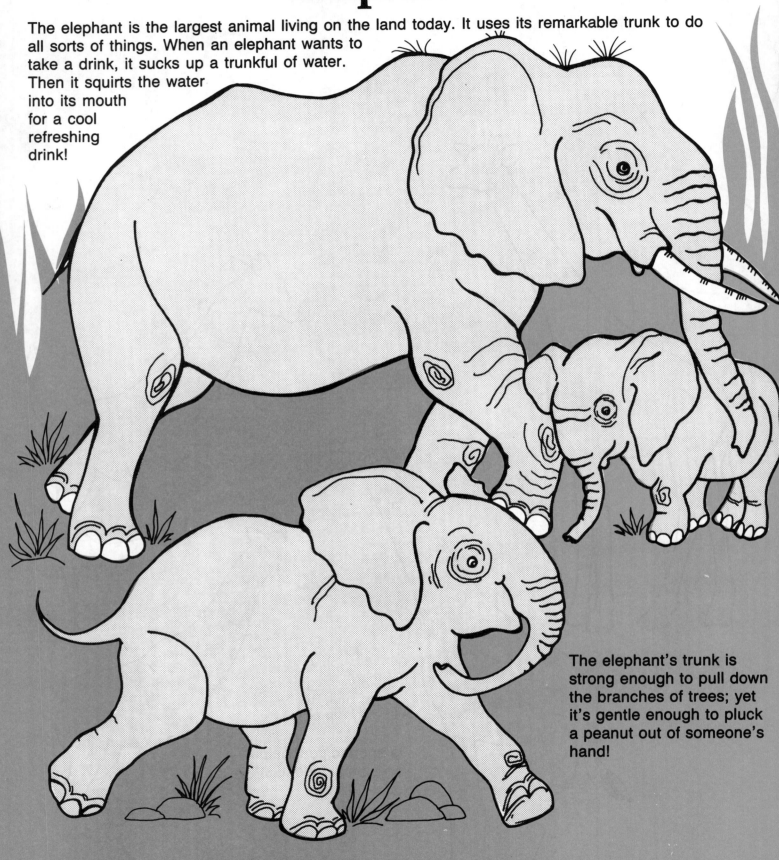

The elephant's trunk is strong enough to pull down the branches of trees; yet it's gentle enough to pluck a peanut out of someone's hand!

1

2

3

Elephant tusks are made of *ivory*, a valuable material.

1

2

3

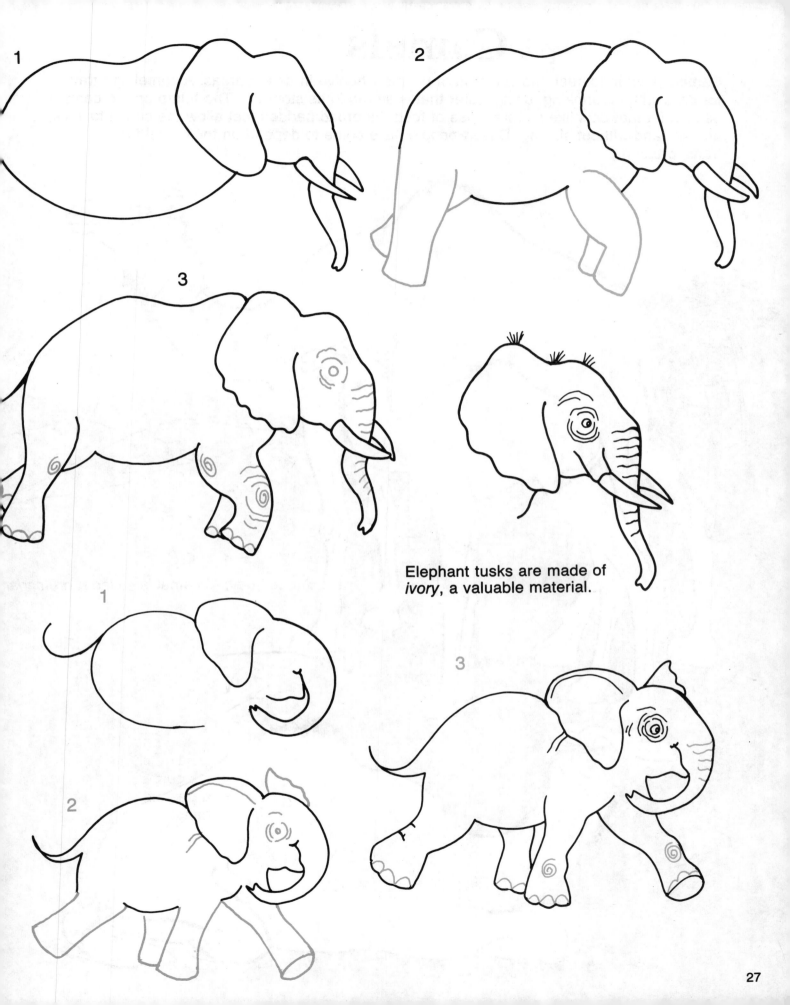

Camels

Camels have long been the servants of people who live in desert areas. A camel can travel for days without drinking, using water that is stored in its stomach. The hump on the camel's back is fat that acts like a storehouse of food. Its broad padded feet allow the camel to walk across sand without sinking. Desert people have come to depend on the camel for transportation.

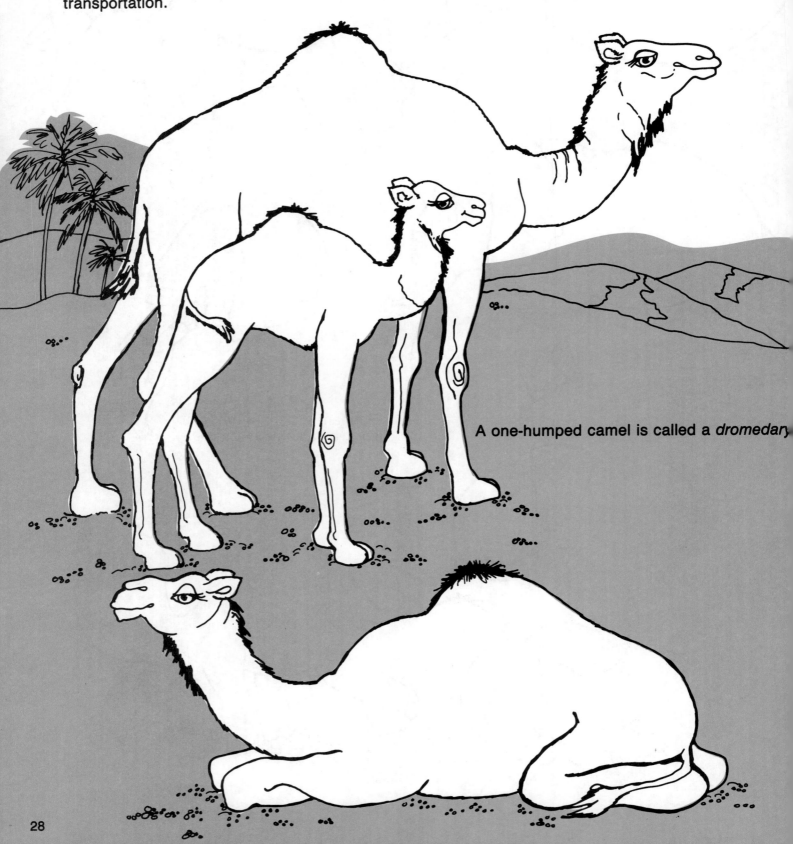

A one-humped camel is called a *dromedary*

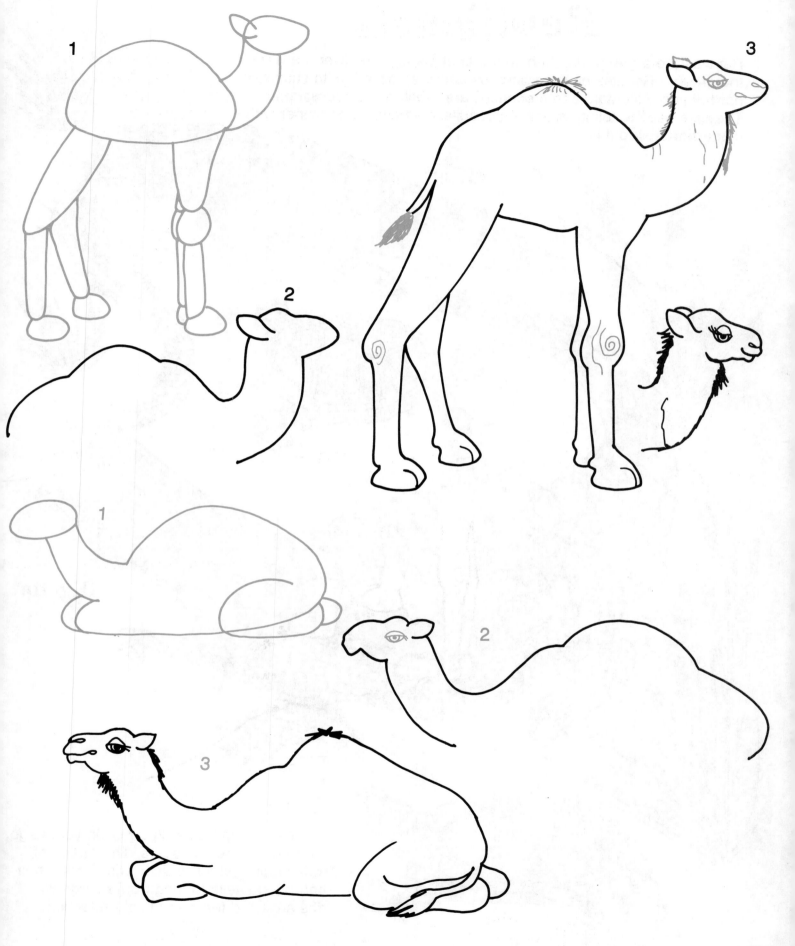

1

3

2

1

2

3

Reptiles

Reptiles are a group of cold-blooded animals that creep or crawl on the ground. Reptiles have backbones and are covered with scales or hard plates. Alligators and crocodiles are reptiles found in swamps. They are easy to tell apart—the crocodile is smaller and thinner with teeth that push out like a bulldog's.

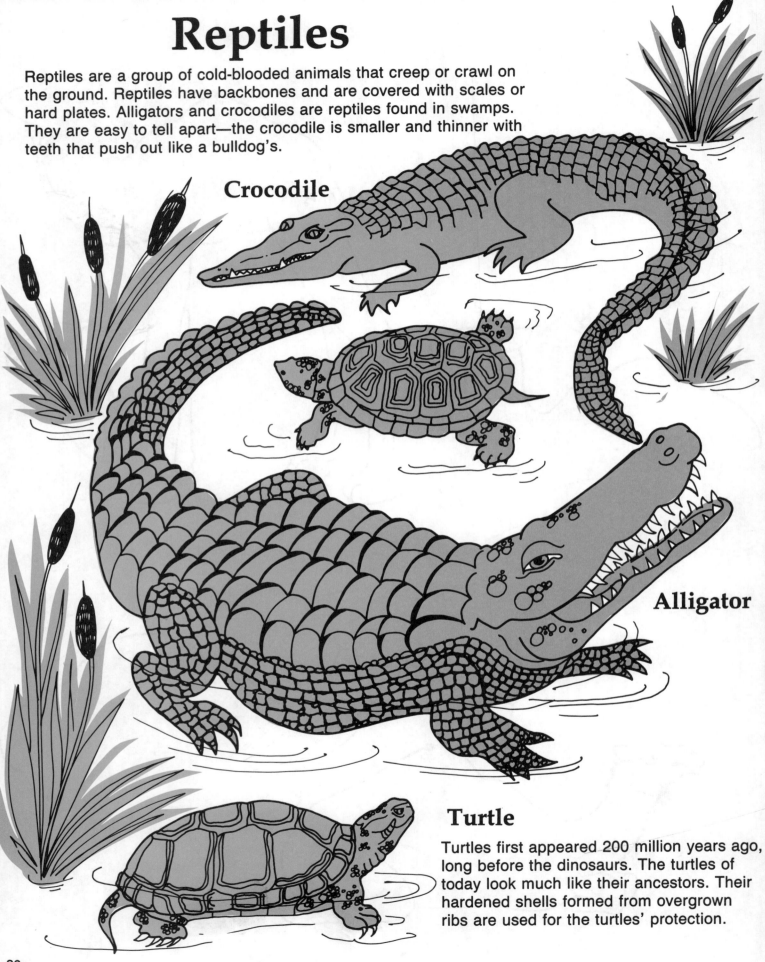

Crocodile

Alligator

Turtle

Turtles first appeared 200 million years ago, long before the dinosaurs. The turtles of today look much like their ancestors. Their hardened shells formed from overgrown ribs are used for the turtles' protection.

Crocodile

1

2

3

Alligator

1

2

3

Turtle

1

2

3

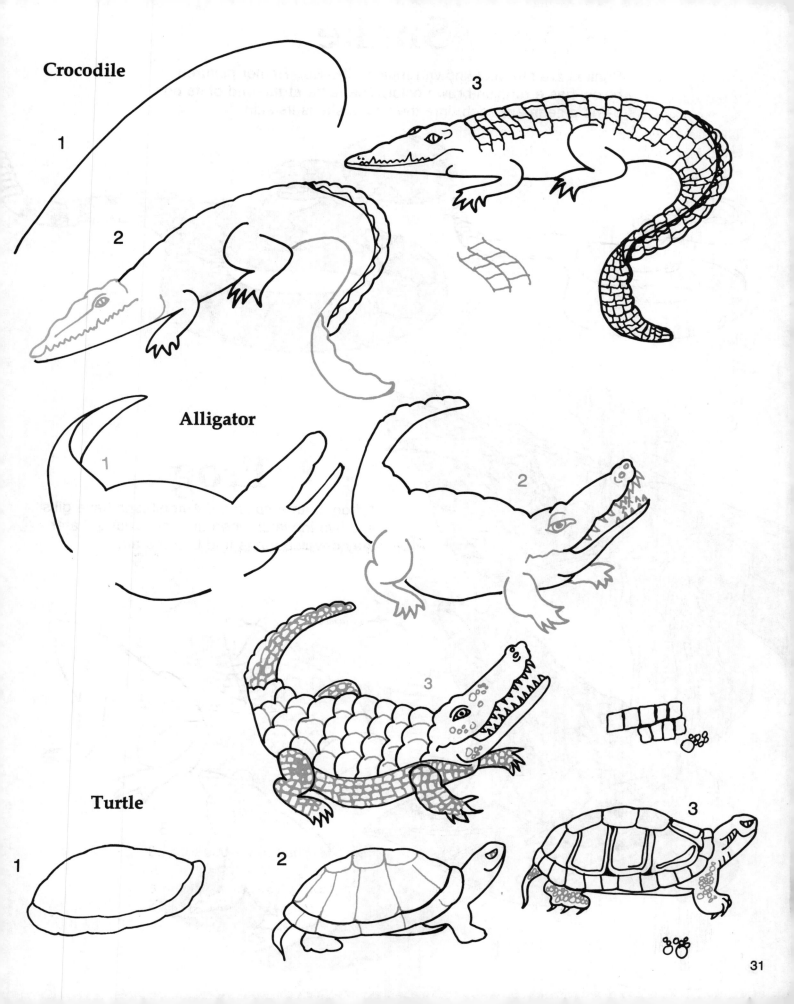

Snake

Snakes are the best-known reptiles. The Red Rattler pictured below has a reddish-brown color. The rattle at the end of its body gains a segment each time the snake sheds its skin.

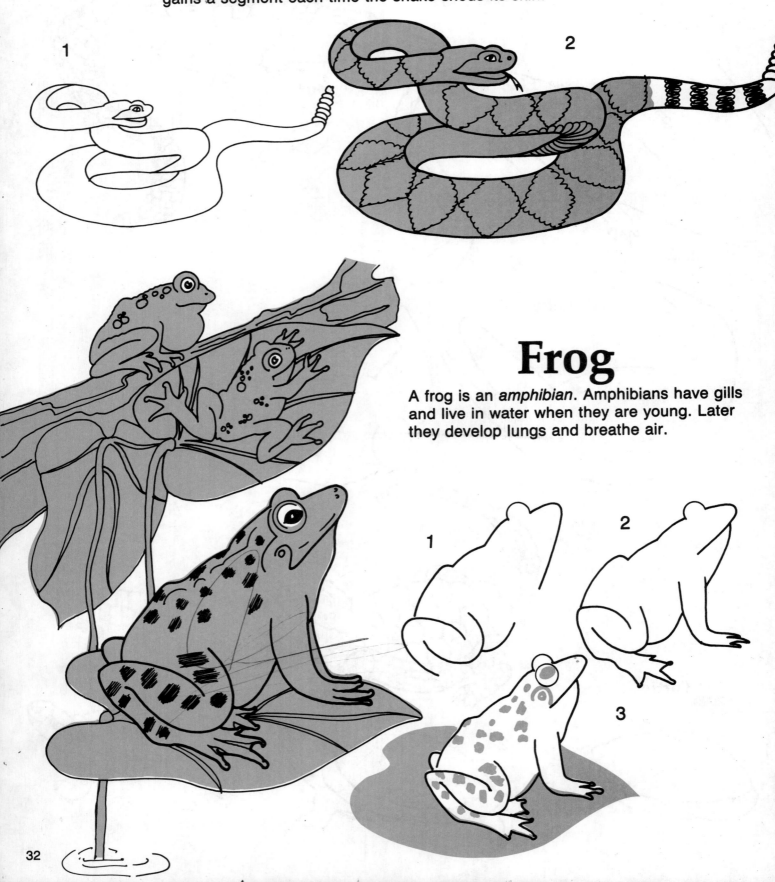

Frog

A frog is an *amphibian*. Amphibians have gills and live in water when they are young. Later they develop lungs and breathe air.